Welcome Home

With the Relaxed Artist

A Coloring Book of Beautiful Homes
By Pam Brown

Introduction

Right now many of you are discovering the joy and therapeutic value of coloring books for grown-ups. In this busy world with our hectic schedules, they are a wonderful way to unwind and relax at the end of the day. In looking at the many choices in coloring books currently available, I was finding very few that came close to what I was looking for. Most were in the form of geometric shapes or they were very stylized. I wanted to color very natural, realistic pictures so that when I was done, I would have a collection of beautiful colorings or paintings. I could even frame my favorites. I have found that I am not alone in my search for this type of coloring book. Many friends and acquaintances have expressed the same wishes.

For my first coloring book, I've chosen beautiful historic and classic looking homes. I have always been drawn to these types of homes. Whether stately, or quaint, they give a feeling of serenity and peacefulness which are needed by all. Homes are a refuge and sanctuary from the stresses that we face each day.

So I hope you enjoy your time spent coloring the pages in this book. I have several ideas for future books. I would also love any suggestions that you might have. You are welcome to email me at the address below.

Thank you so much, and happy coloring!

Pam Brown

therelaxedartist@gmail.com

Tips and Suggestions

The following are some tips and suggestions for using this book. If, however, you have further questions on ways or ideas to enhance your pictures or your drawing skills, please visit my website therelaxedartists.com or email me at therelaxedartist@gmail.com.

1. Don't always just use one color for an object. For instance, if you are coloring the home in blue, mix different shades of blue, or use some grey so that it appears natural. Remember, with these homes, there would be different amounts of sunlight on various parts of the object that you are coloring.

2. Try blending colors together. When using watercolor, the colors will naturally do some of their own blending. However, if you are using colored pencils, you can blend the colors with your finger or a tissue. For best results, use blending tools. These can be found in the drawing sections of art stores.

3. If an area seems too dark or bold, lift some of the color with an eraser. This method will give your artwork a more natural appearance. You can use any eraser, but I do recommend higher quality erasers that can also be found at art supply stores.

4. As I referred to in tip #1, sunlight will land on objects from one direction so don't forget to add some shading on the sides that don't receive as much sunlight. You can do this by using the same color and just adding more of it. Or you can add some grey to the darker side. You can also use a bit of a complementary color. For instance, if you are coloring an object red, you can shade the darker side of an object by using a bit of green. This method creates a natural looking shade. Basic complementary colors are: blue & orange, red & green, yellow & purple.

5. Liquid correction fluid can also be used to fix certain areas of your pictures. Try using a small amount on an area if you want to cover up color on an object that you want completely white when erasing doesn't take out enough color.

6. When there are trees in front of the home, color those last. In fact, I usually work from top to bottom on my pictures. I color the sky first starting with a darker color near the top of my pictures. Then I work down to the bottom of the page which will be the foreground of the picture. If part of the home is behind a tree, color some of the areas of the home leaving spaces to be colored in with whichever colors you are using for the trees.

7. If, when you are done adding color, either through watercolor or colored pencil, and there is an area that you would like to soften, try a bit of chalk pastels. They can be used to soften or highlight certain areas of your pictures. You can even add shadows easily using darker pastels.

8. Use the margins of the pages as an area to test blending different colors before you use them.

Again, these are just a few tips and suggestions. You can always visit my website therelaxedartists.com or email me at the above email address for more help.

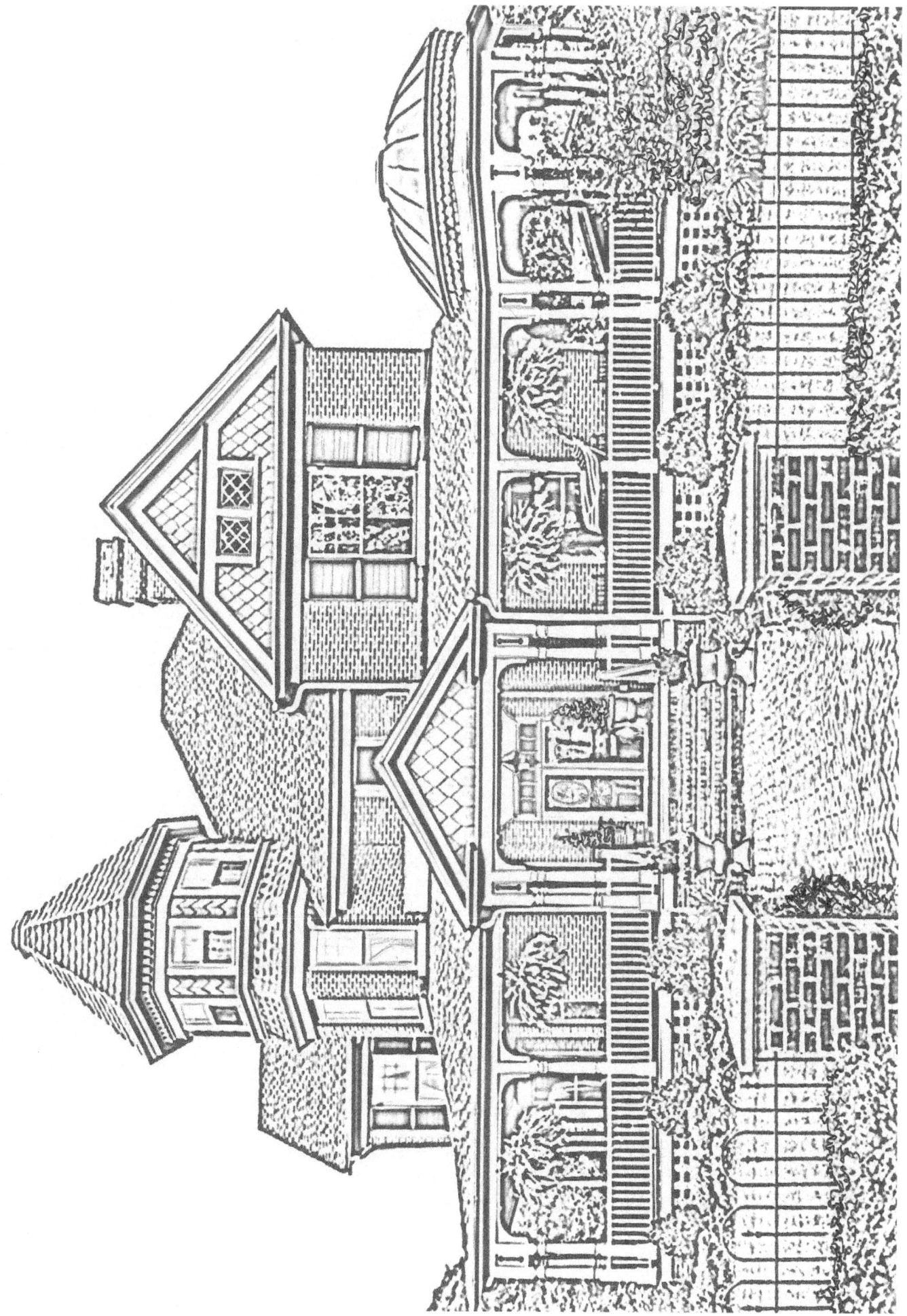

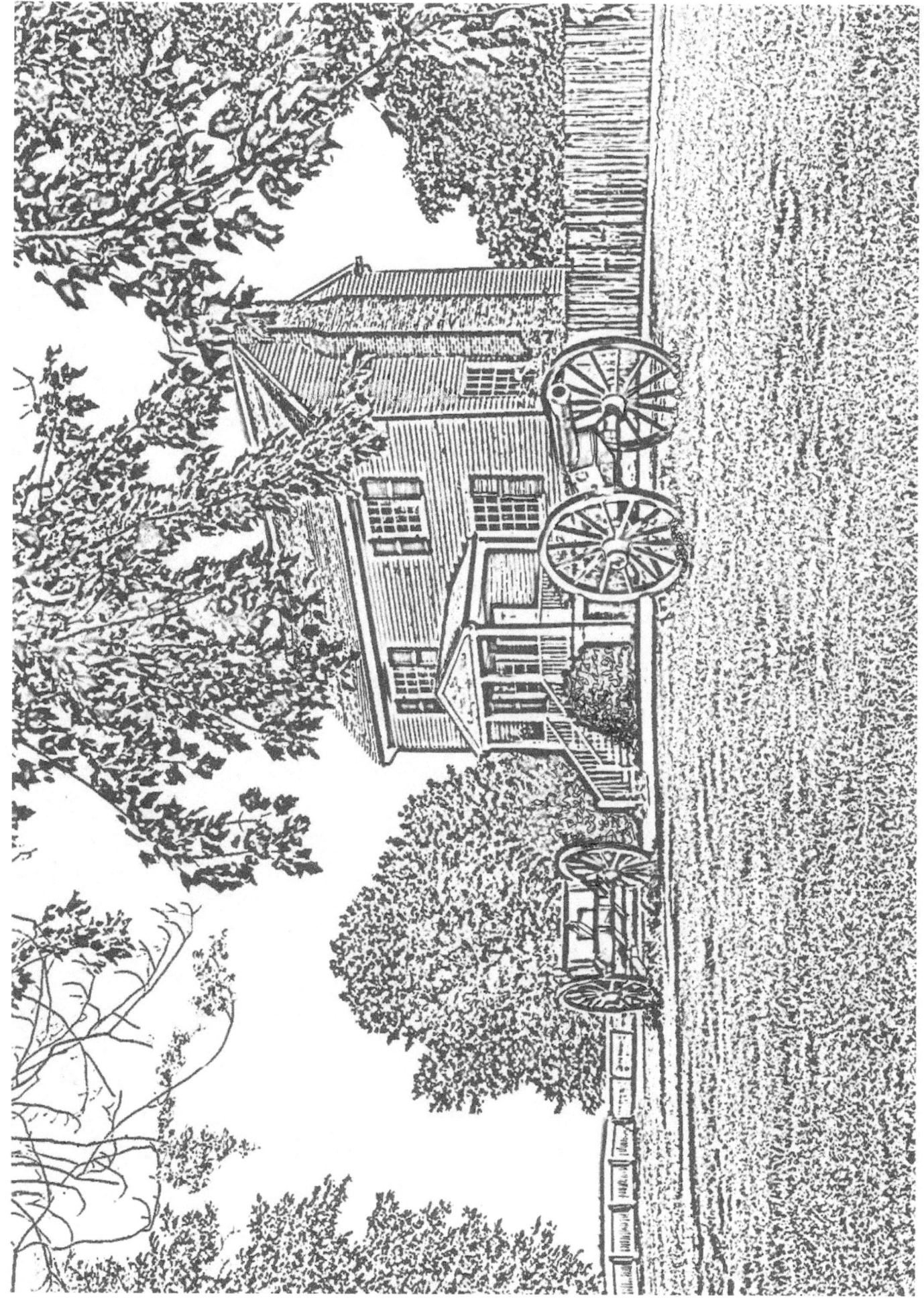

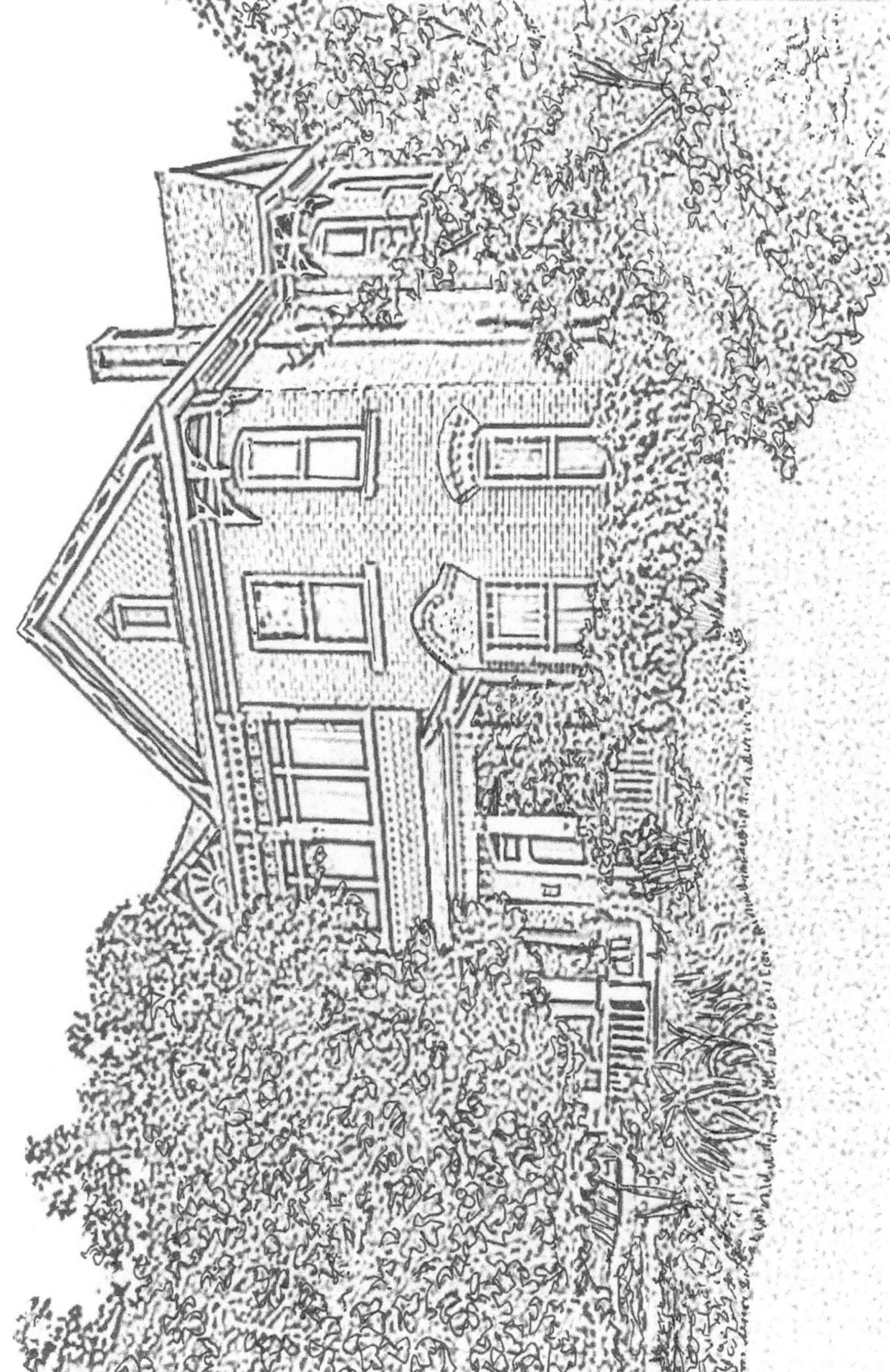

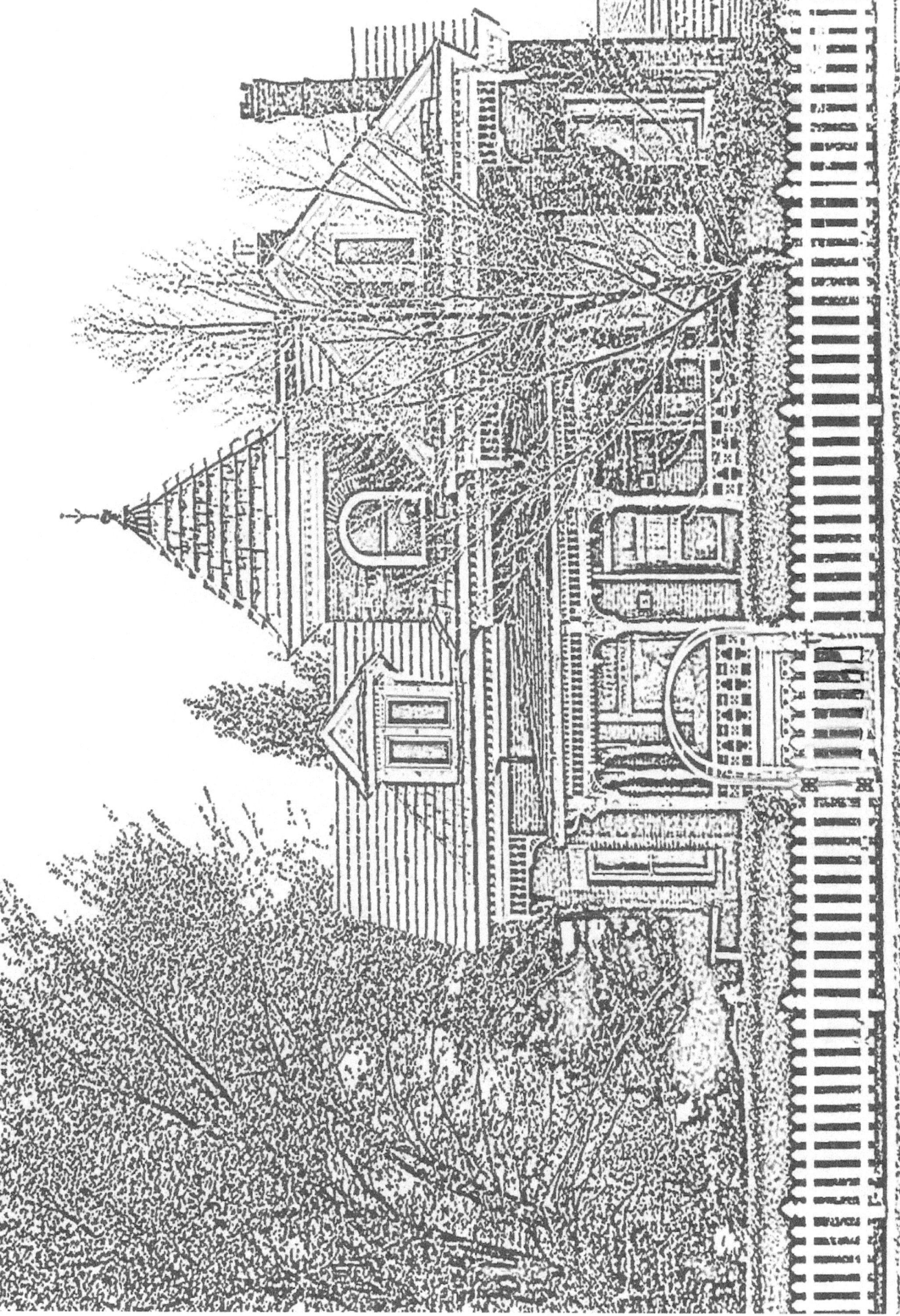

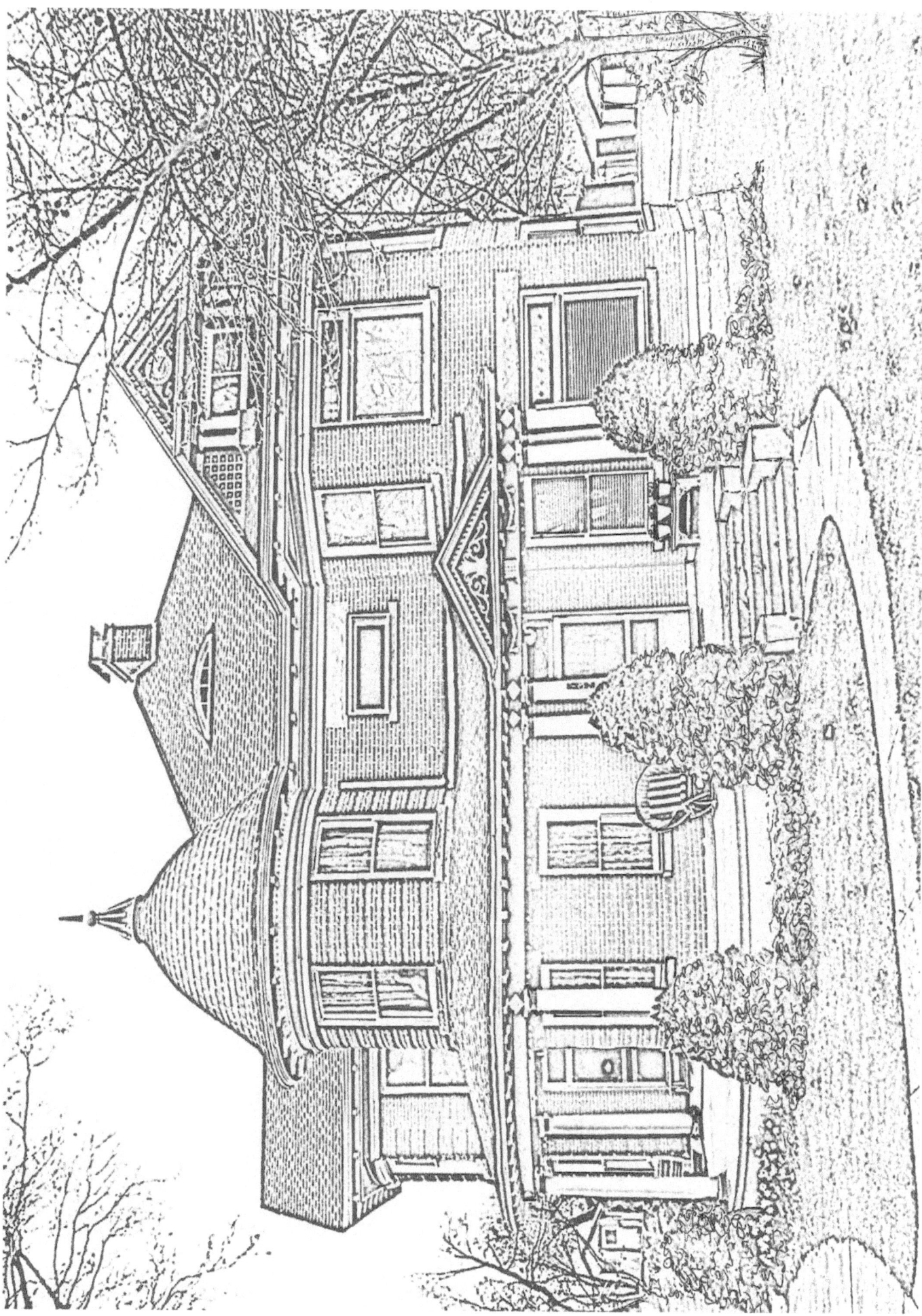

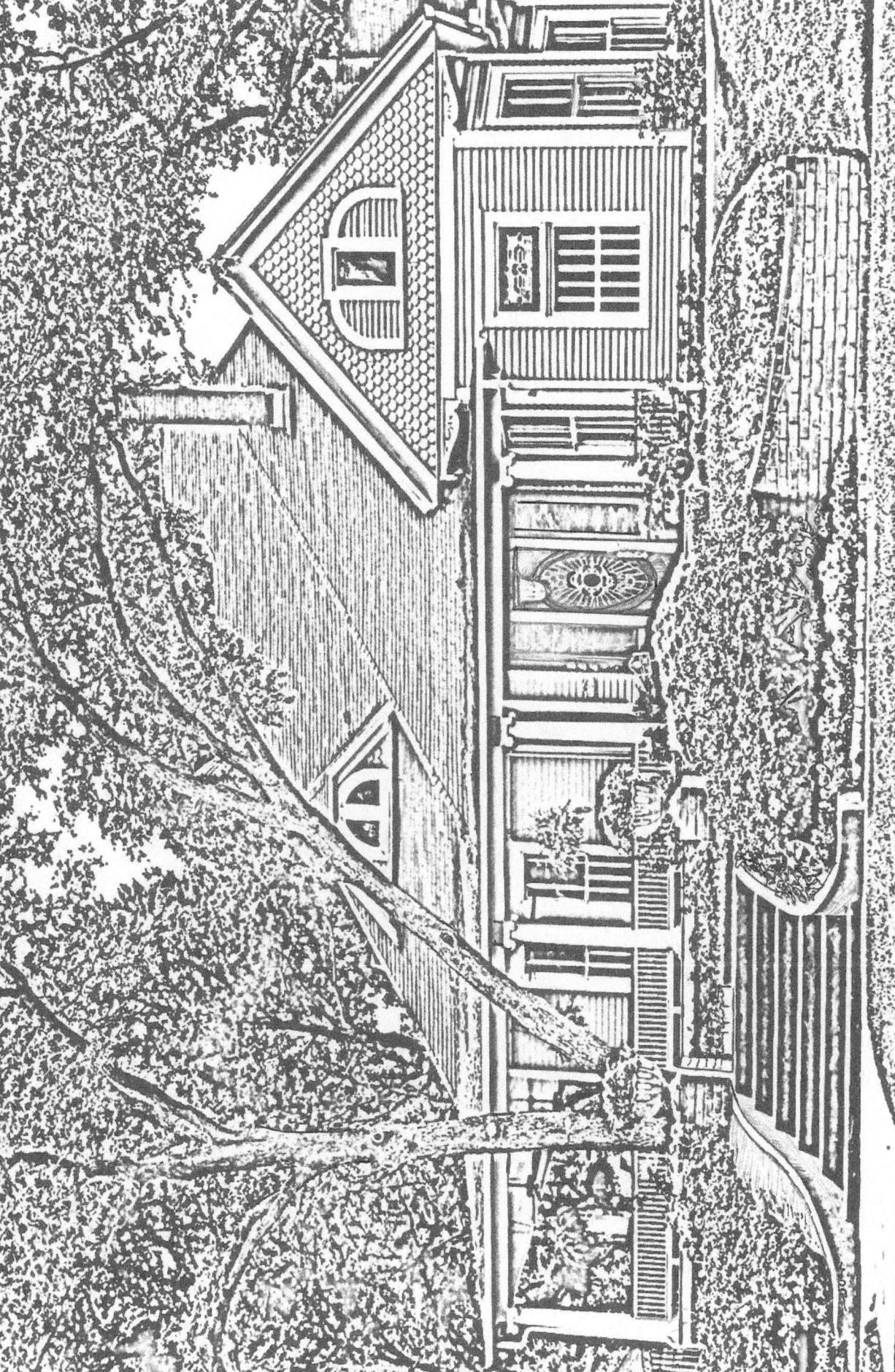

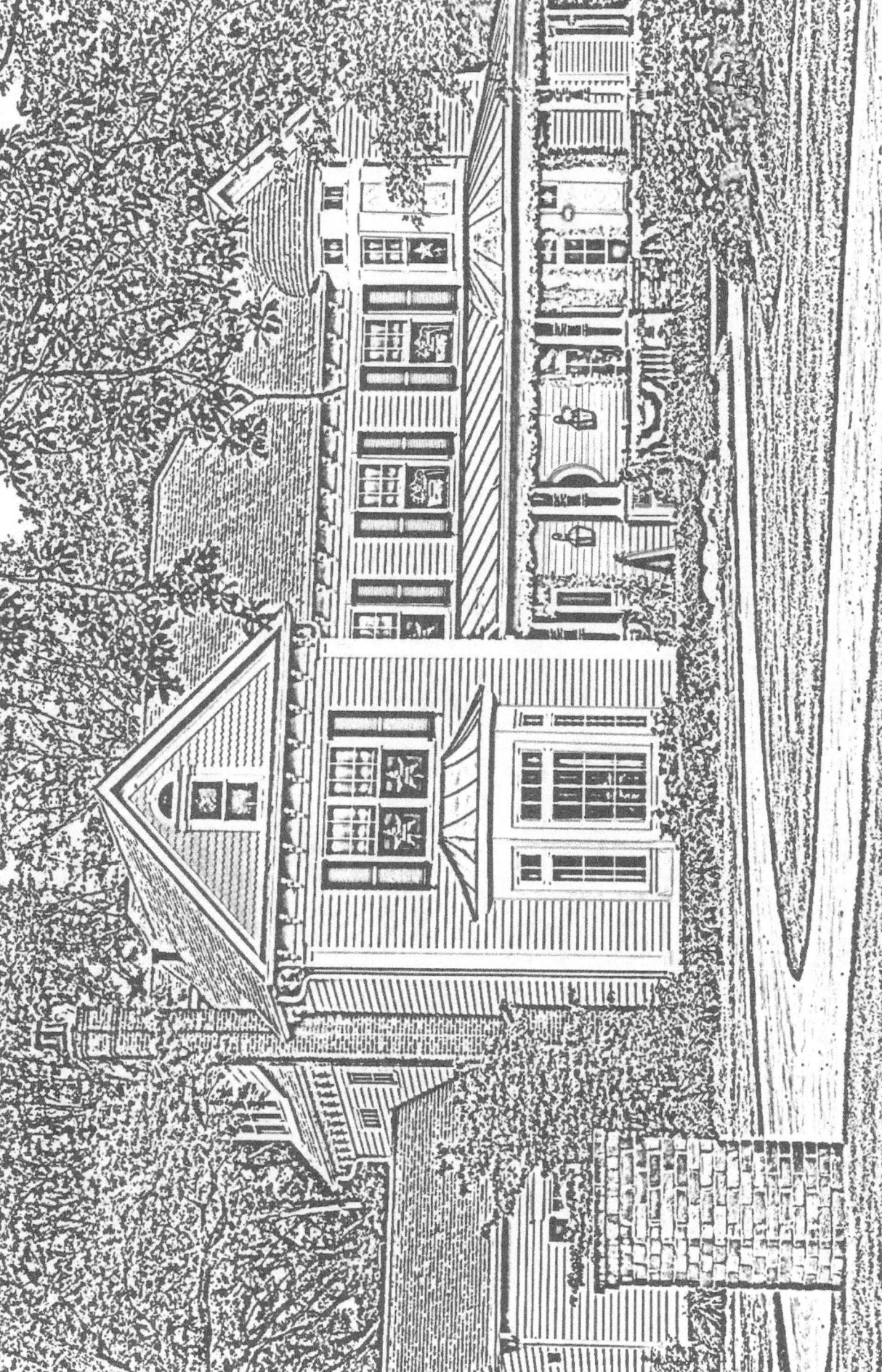

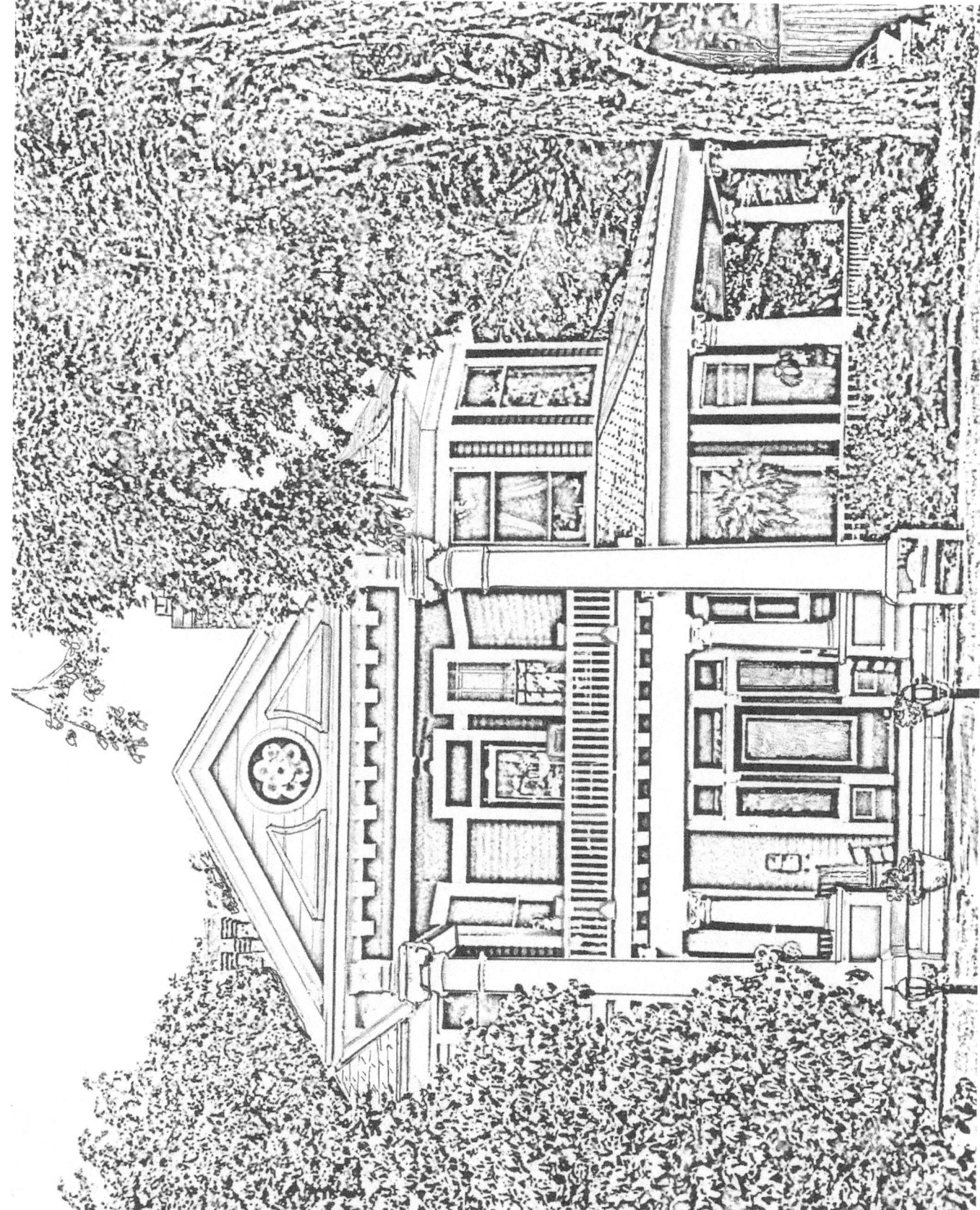

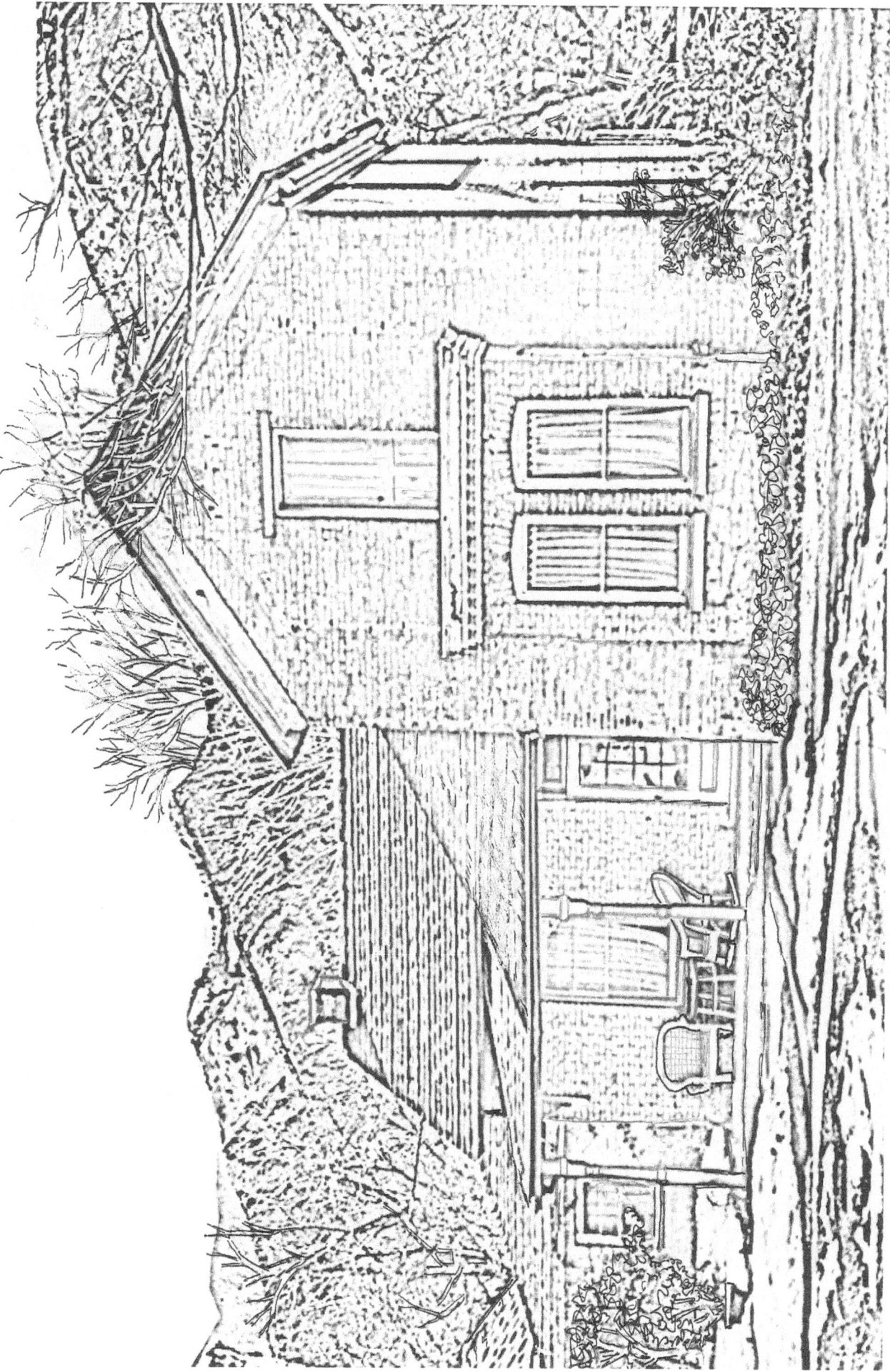

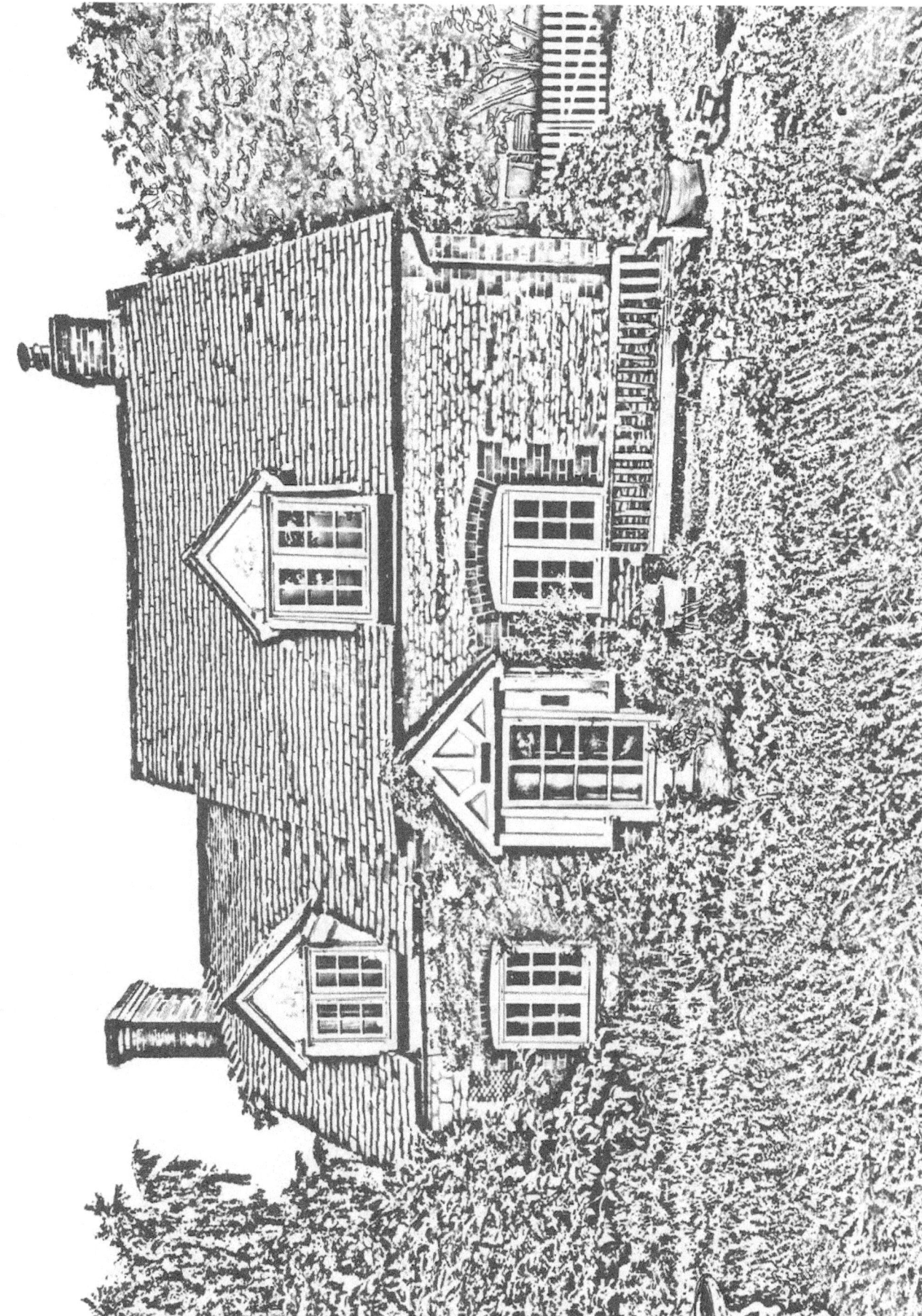

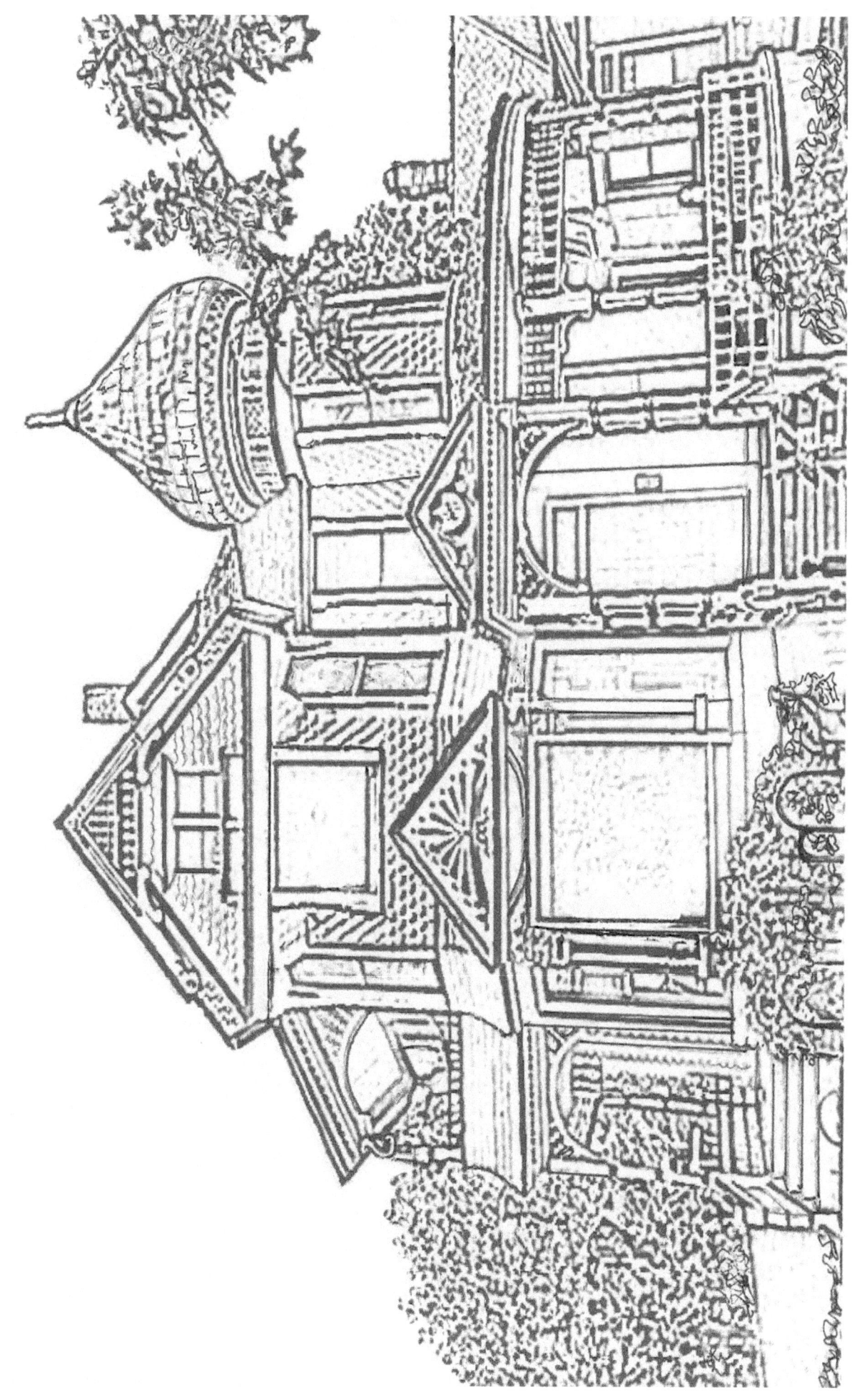

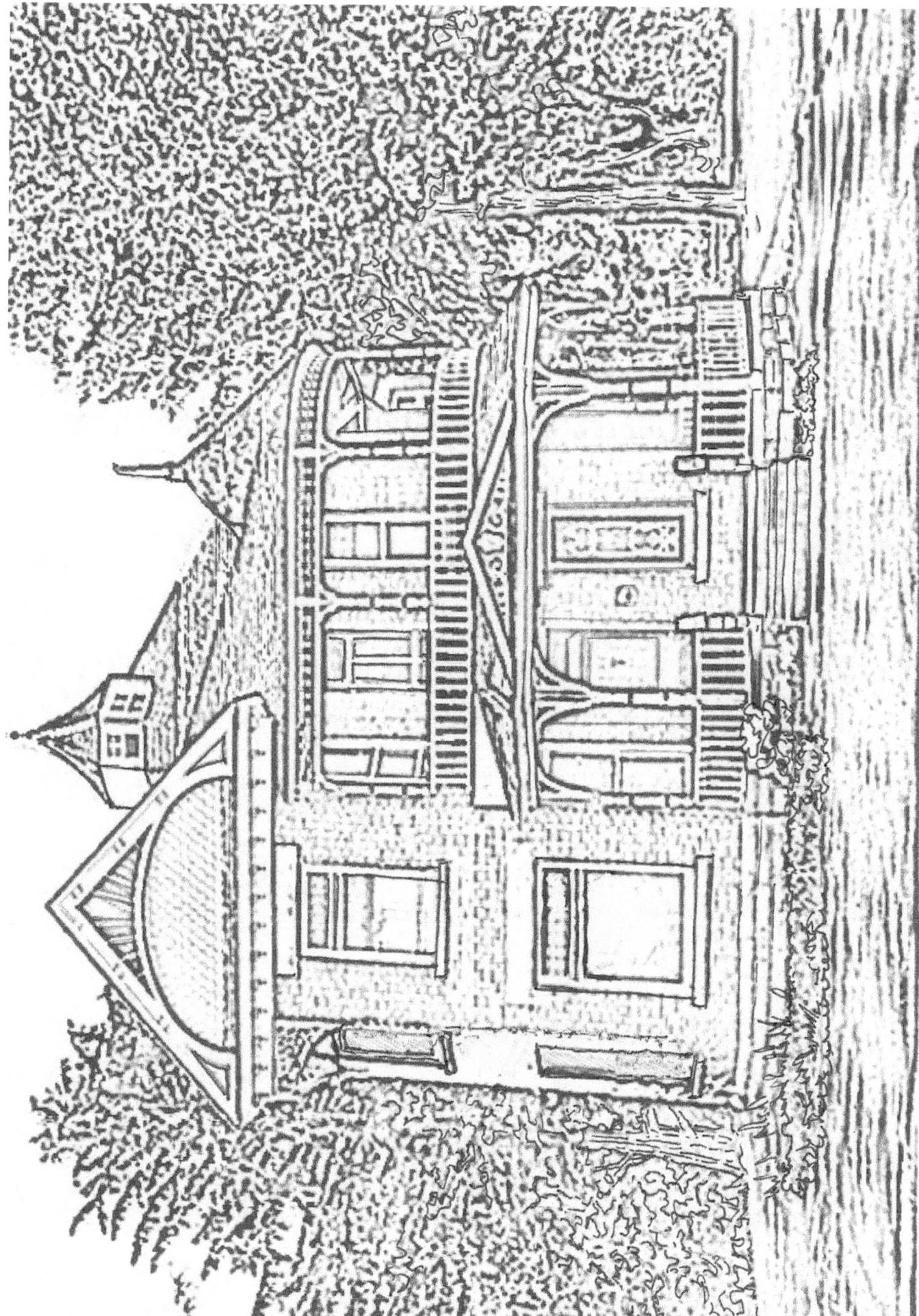

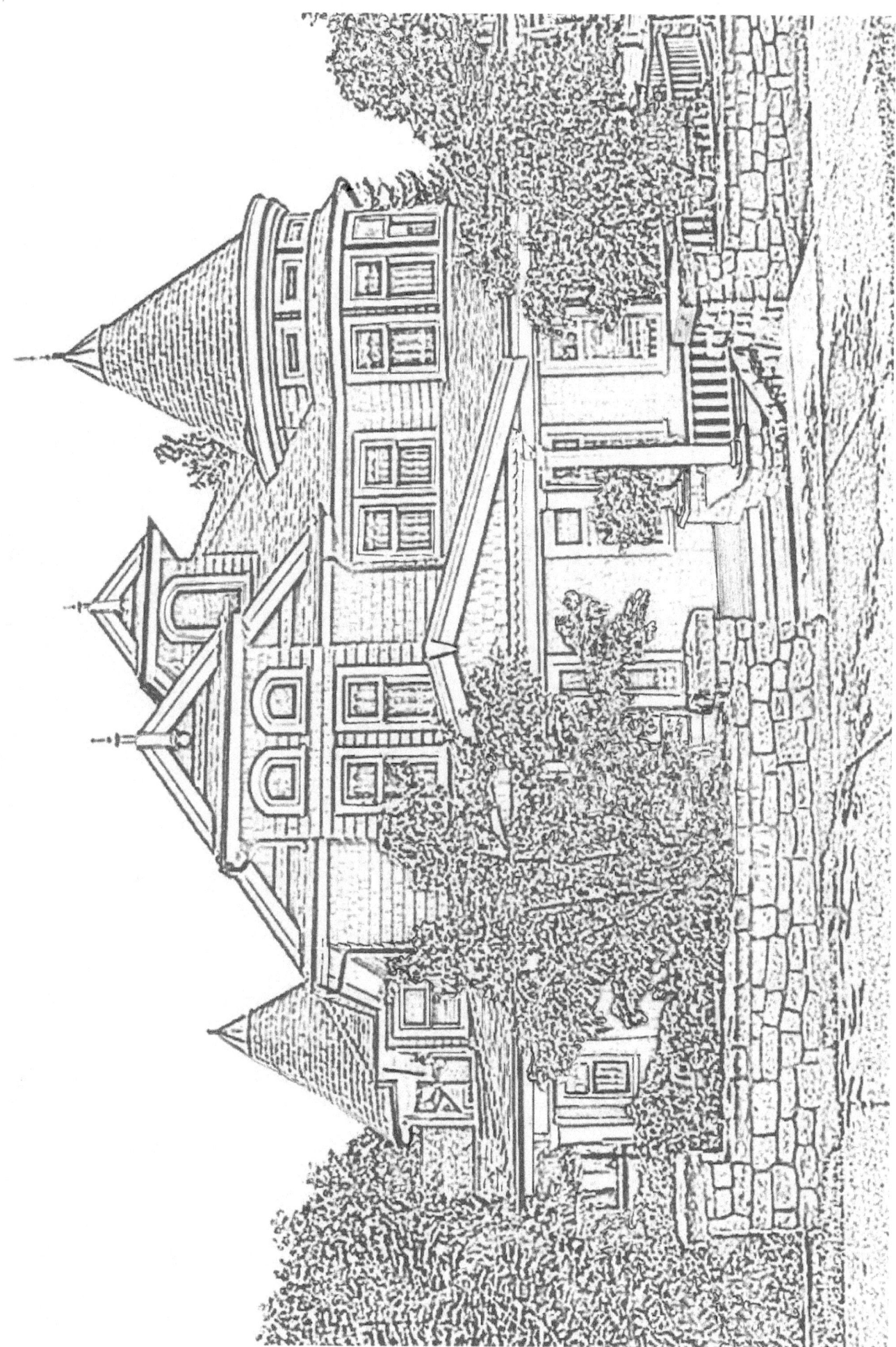

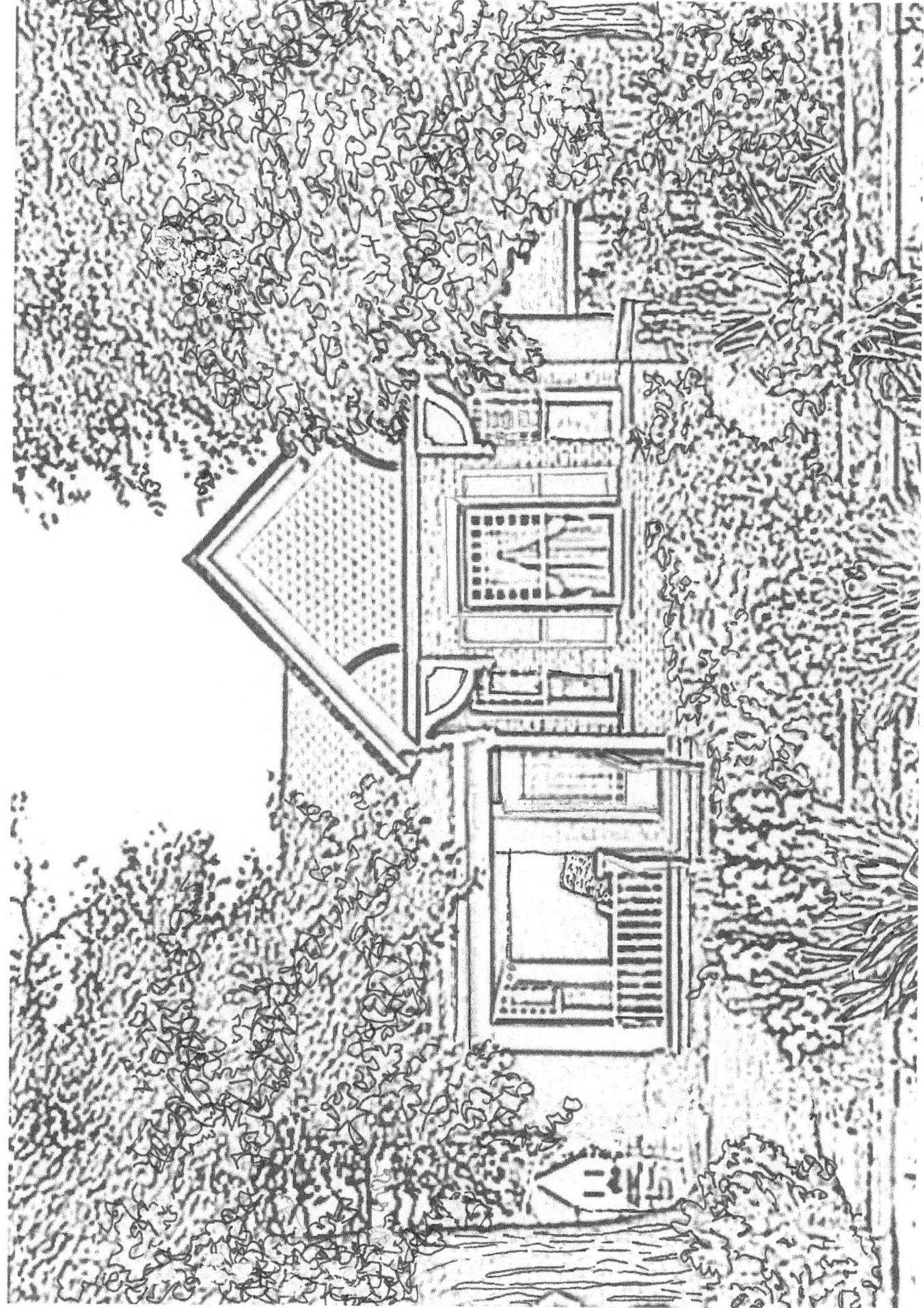

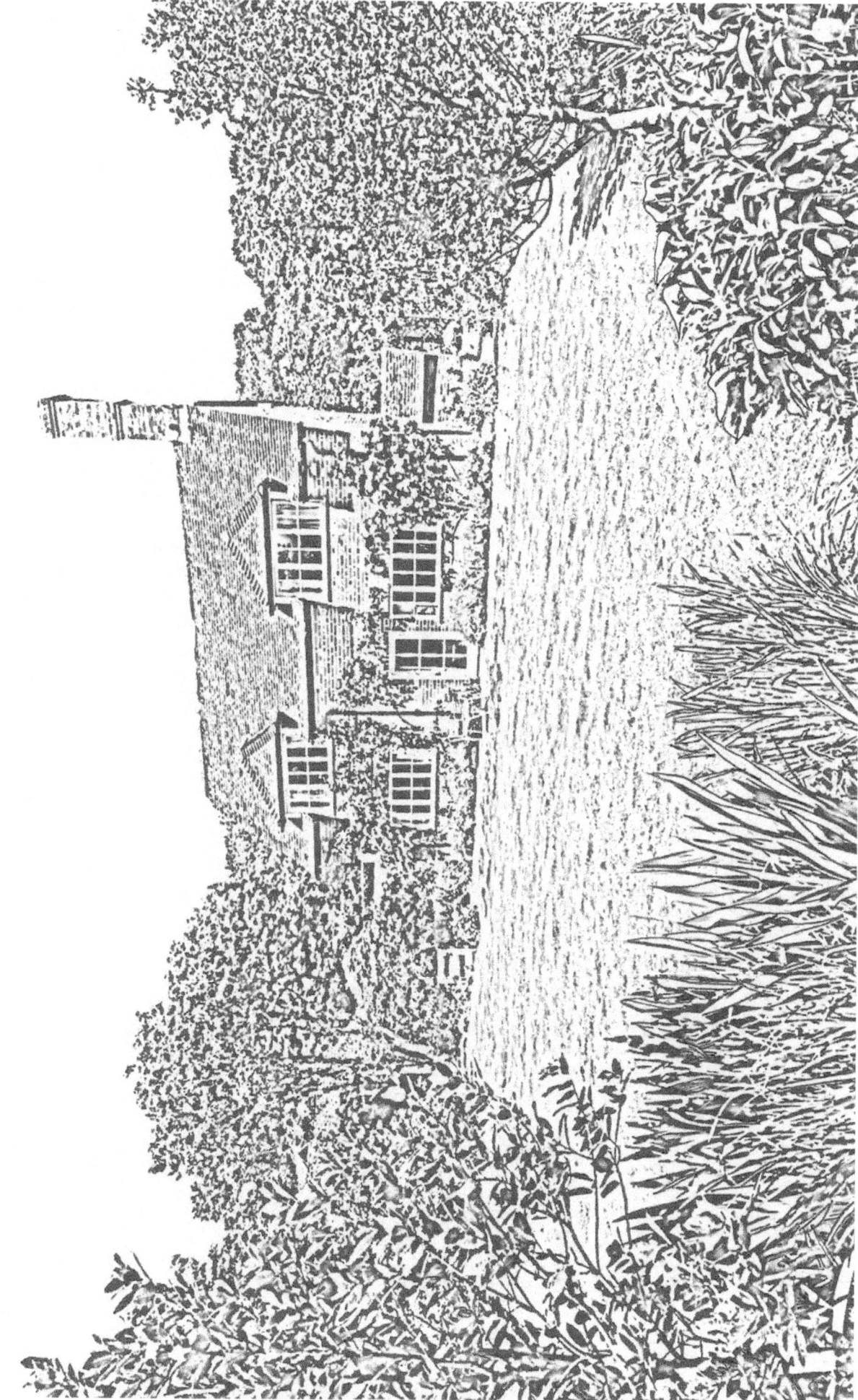

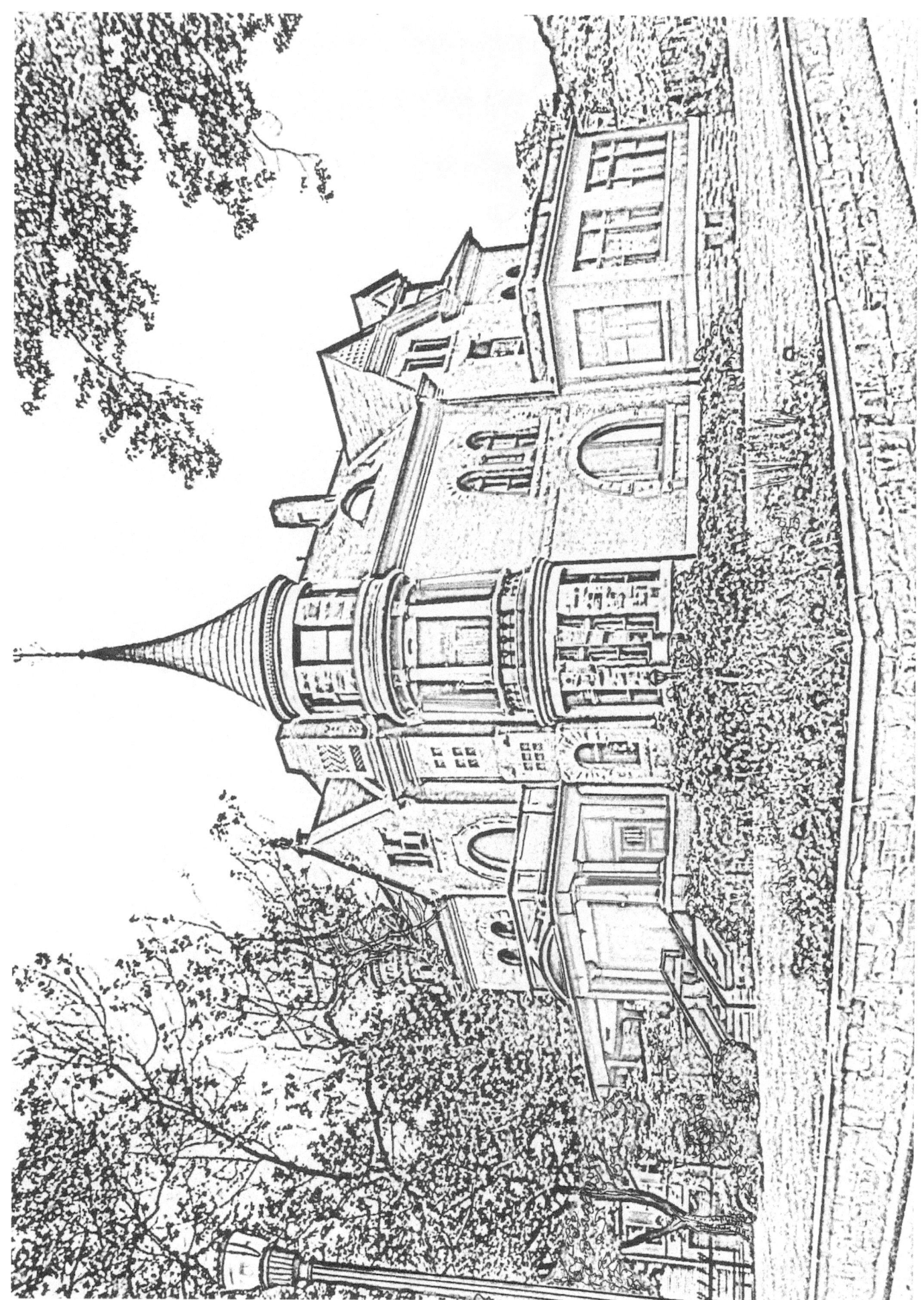

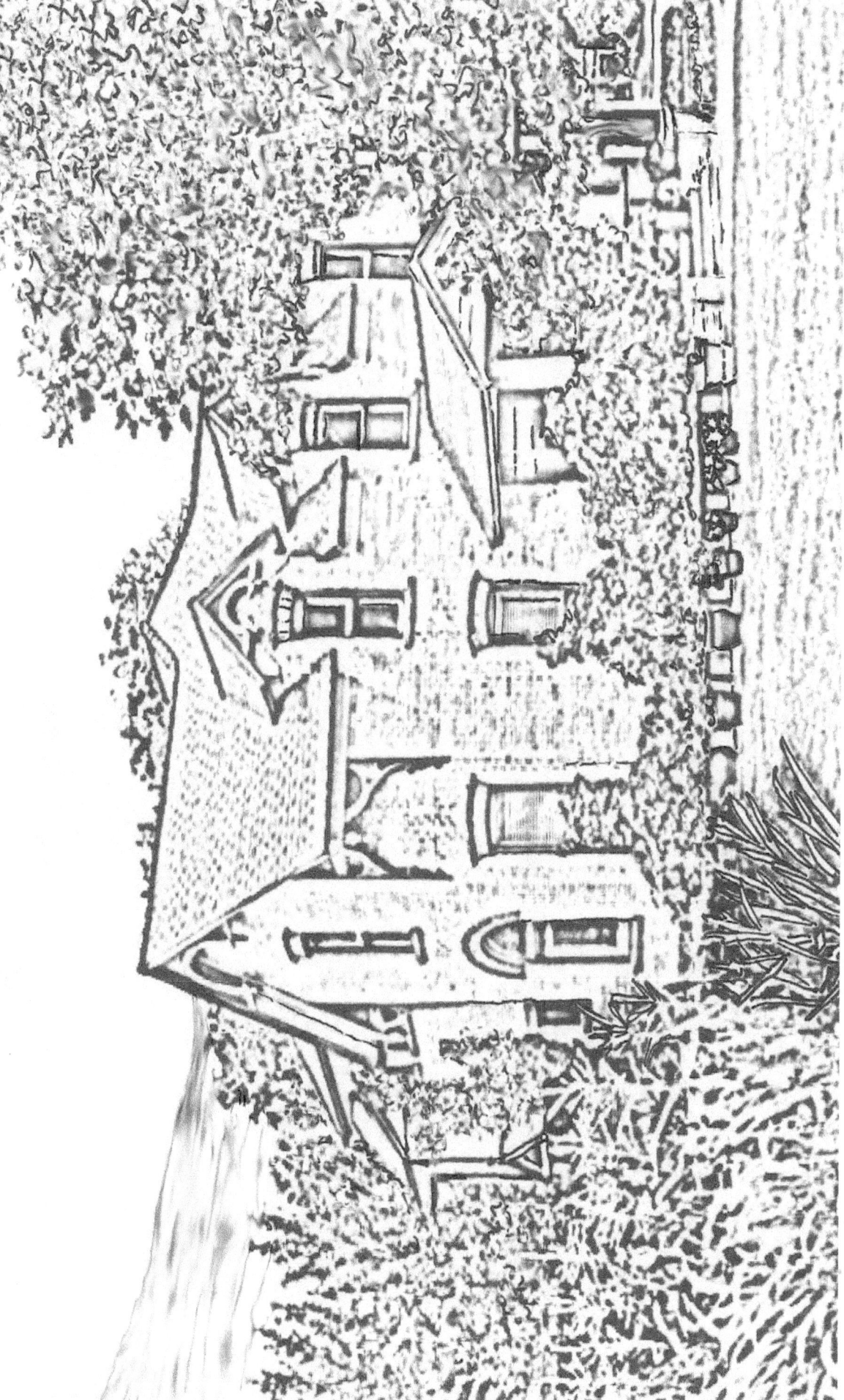

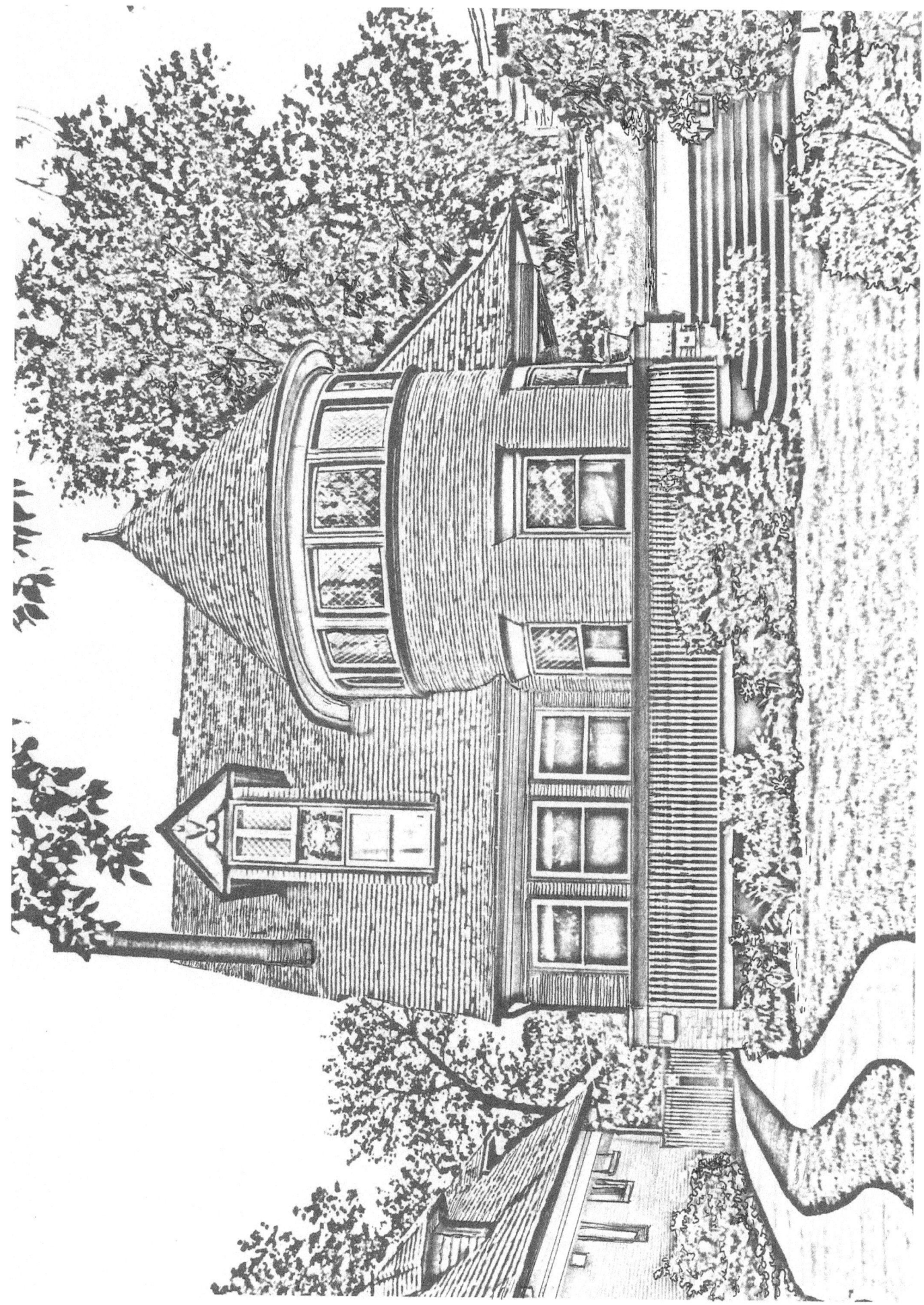

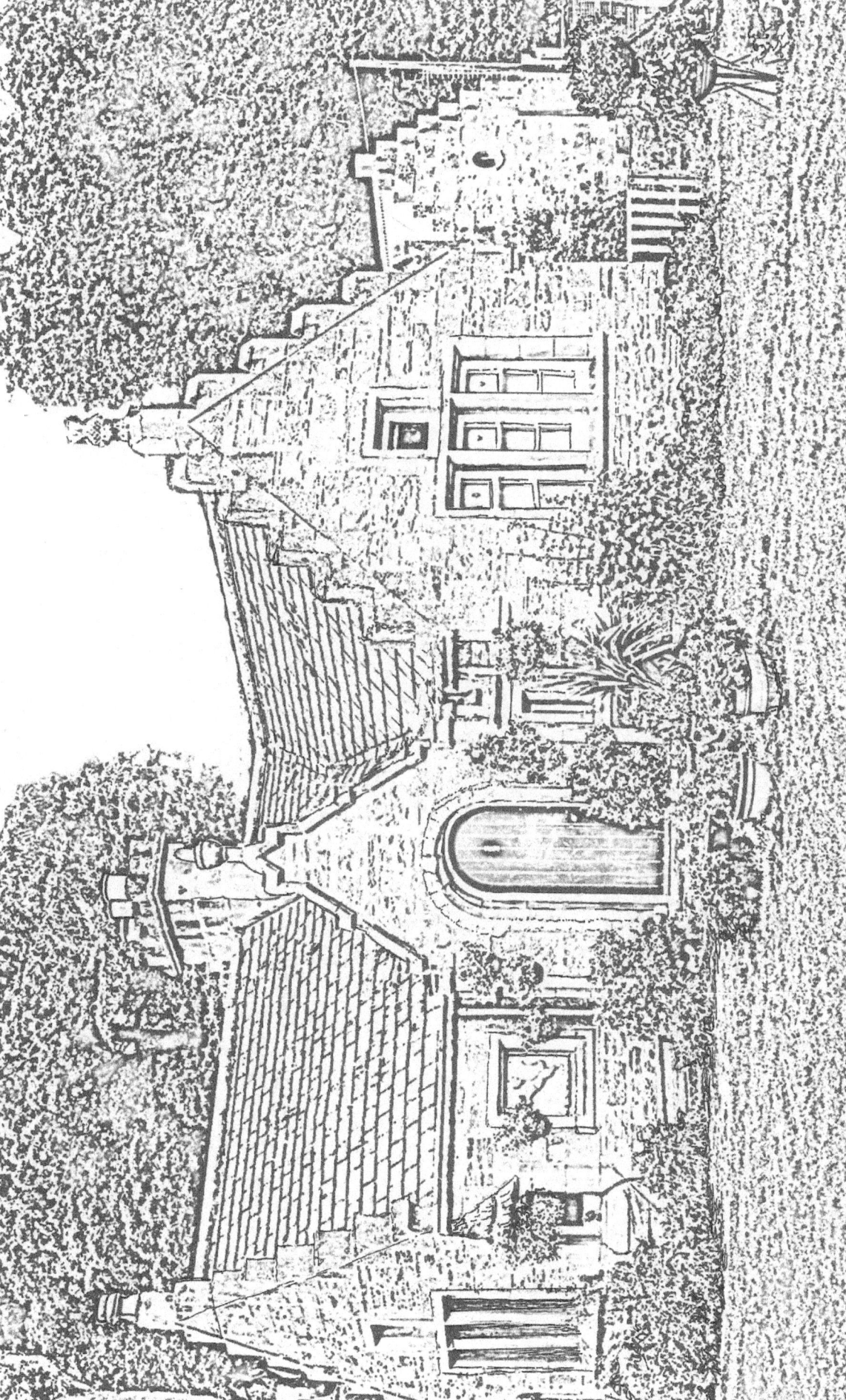

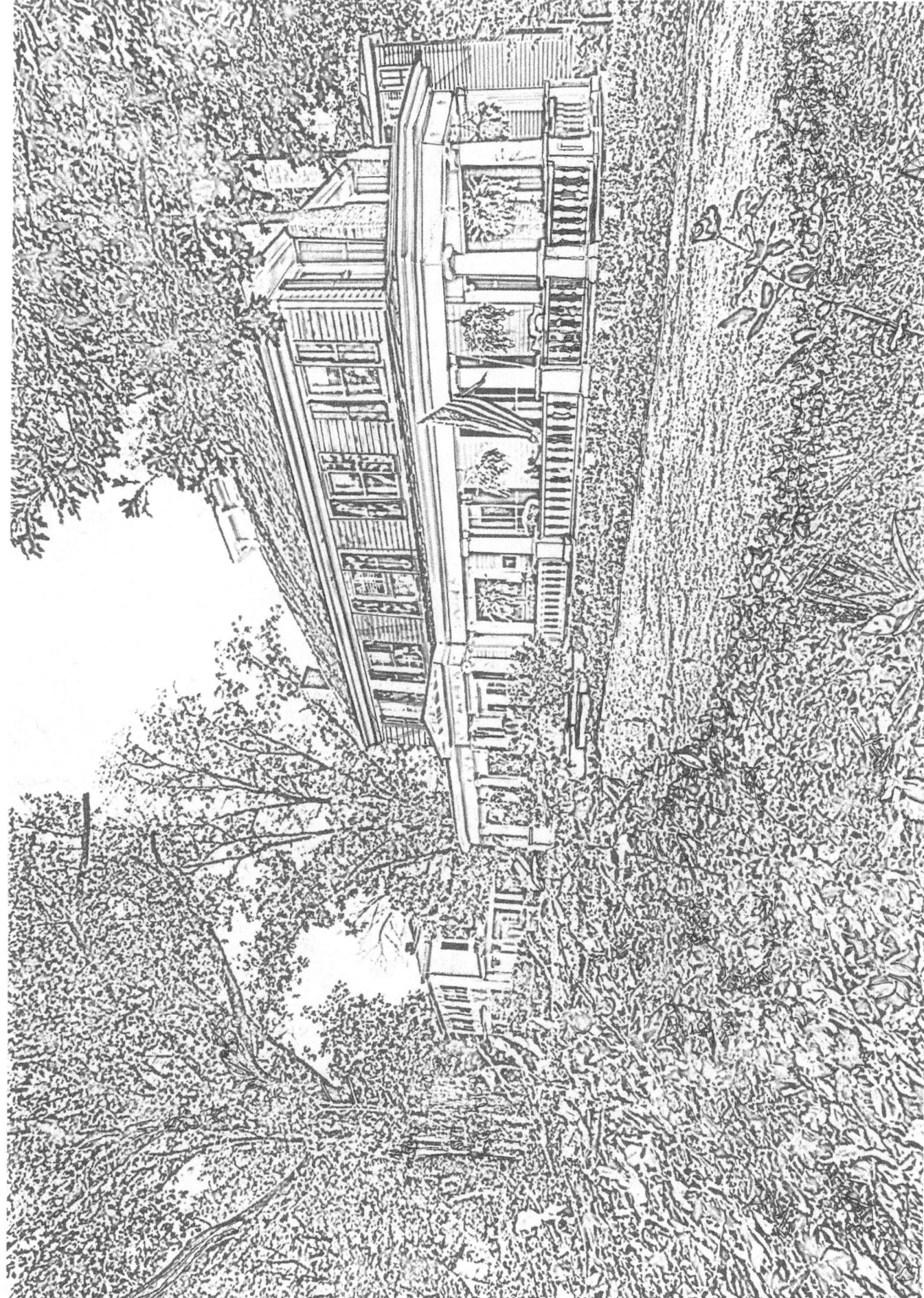

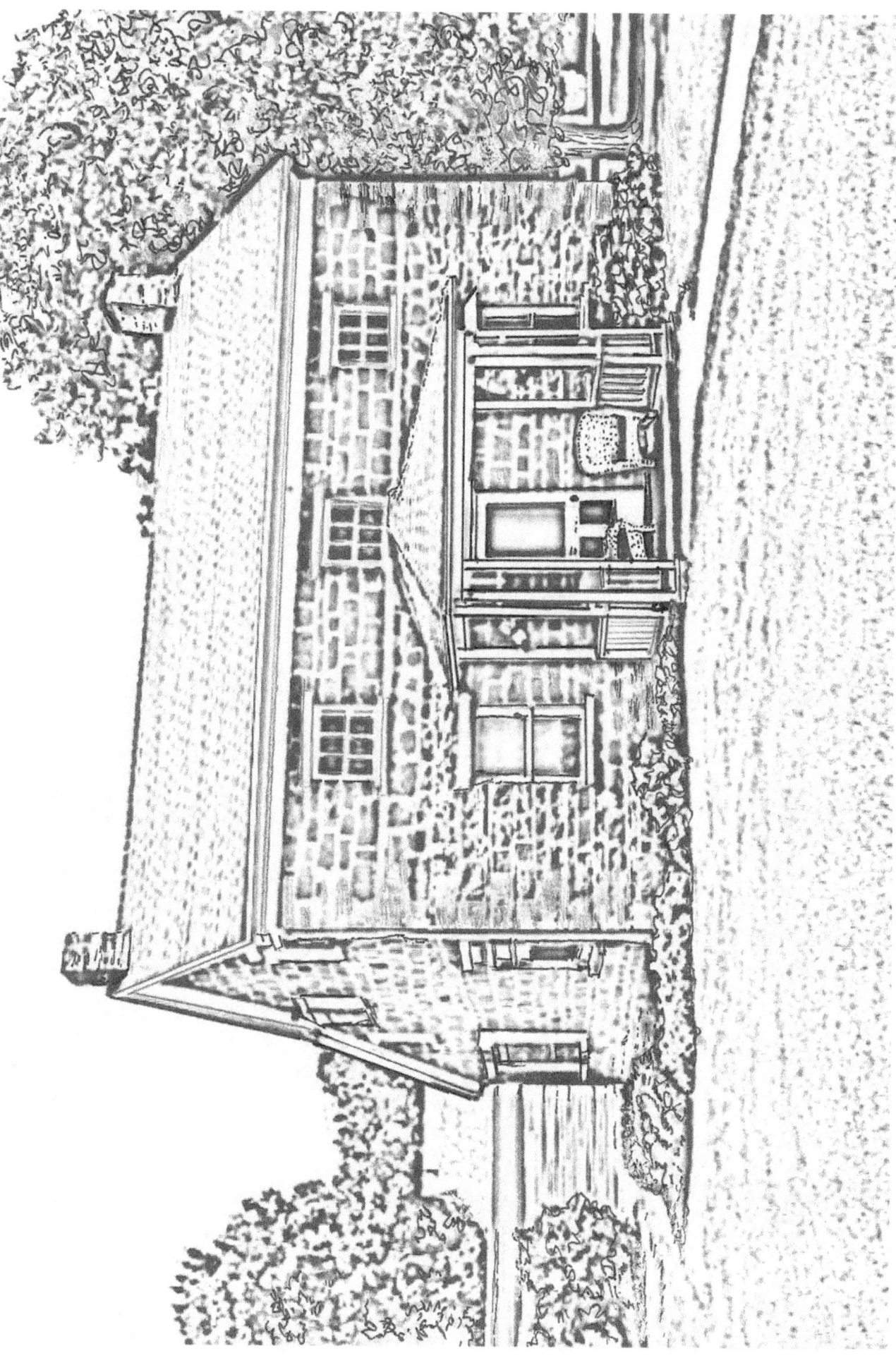

www.ingramcontent.com/pod-product-compliance
Lightning Source LLC
Chambersburg PA
CBHW080609190526
43169CB00007D/2944